Out of The Darkness. This is her story V 1.3

By

Jason Isaac Kooy

Inspired by the novel "The Plan of Happiness"
By Patricia C. Ridgway

Cast of Characters

Bethany Carlson: 17 year old Mormon living in Salt Lake City. Close to her family and her twin sister

Abigail Carlson: Bethany's (Fraternal) Twin - very close to her sister and family

William Carlson: Bethany and Abigail's Father. Mormon father.

Beverly Carlson: Bethany and Abigails Mother, wife of William

Reuben Young: Bethany's initial love interest. 17 year old Mormon boy.

Lyra: New to Salt Lake City. 17 year old non-mormon girl with a secret

Georgia: 17 year old mormon - starts a love triangle relationship with Reuben and Bethany

ACT I

Scene 1

The stage is empty and dark. Spotlight comes up downstage center and REUBEN enters and slowly walks into the spotlight. The other characters, with the exception of BETHANY, walk behind REUBEN and form a line behind him in the darkness.

REUBEN
 I want to tell you about my friend Bethany. (Beat) I Can't.

 REUBEN Can't continue talking and steps back into the line. The stage is quiet and dark for a long beat.

 WILLIAM walks into the spotlight. He waits for an uncomfortable moment.

WILLIAM
 I want to tell you about my daughter Bethany.

 Starts to talk, but can't form the words. Steps back into line. Back into the darkness that is upstage.

ALL CHARACTERS
 This is her story.

 All lights go down.

All Exit.

Scene 2

Lights come up on BETHANY and her twin sister ABIGAIL. They are in a middle of a conversation. They are in the bedroom that they share together.

ABIGAIL

 What'd you say?

BETHANY

 I said Yes.

ABIGAIL

 (Screams in excitement)
 Beth !! I'm so excited for you. Seriously

BETHANY

 Calm down. he didn't propose. Just asked me to be his girlfriend.

ABIGAIL

 So when's the big day?

BETHANY

 What Big day?

ABIGAIL

 The wedding! Oh Beth I am so jealous, but in a good way!

BETHANY

 Oh sweetie, your time will come. He is pretty hot though!

ABIGAIL

You're killing me!!

BEVERLY Enters

BEVERLY
> You two seem pretty excited.

ABIGAIL
> Mom, you'll never believe it. My twin sister has a boyfriend!

BETHANY
> Abi!!

BEVERLY
> Does she now. Anyone I know?

ABIGAIL
> Reuben Young.

BETHANY glares at ABIGAIL, but in a very playful way

BEVERLY
> Reuben. (Beat) I like him. He is a good boy.

ABIGAIL
> He's a man!! Practically my brother-in-law.

BETHANY
> You two are the worst. We just started seeing each other and ...

WILLIAM Enters

WILLIAM
> Who are you seeing?

BETHANY

Does anyone knock in this family?

ABIGAIL

My lovely sister has a loving boyfriend and they are getting married.

WILLIAM

What?

BETHANY

We're not getting married. Abigail is simply living vicariously through me ... AGAIN!!

ABIGAIL throws a pillow

WILLIAM

So who is this fortunate young man who is taking my daughter away from me.

BEVERLY

Reuben Young.

WILLIAM

Good boy. I like him.

BETHANY

Yes, Reuben is a good boy and you are all going to be very disappointed when it doesn't work out because he runs away from this crazy family yelling and screaming.

Doorbell

WILLIAM

Now who could that be? Better not be that Reuben fellow here to take you away from me.
(feigns being sad)

BEVERLY

Come my love, let's terrorize this young man while we

can.

BEVERLY and WILLIAM Exit

BETHANY
(Yelling after them)
Please be nice, or I tell Abigail she was adopted.

ABIGAIL
I always figured that was why they loved me more than you.

Both Laugh

WILLIAM
(From offstage)
Beth come down here. There is a young man who wants to court you away from me.

BETHANY
Abi, do my a favor. Just kill me now. Quickly.

ABIGAIL
Before I do let me tell you how proud I am of you. Now go, your man awaits.

BETHANY and ABIGAIL run offstage

Scene 3

Family room. WILLIAM and BETHANY are talking to REUBEN.

WILLIAM
So tell me young man, how long have you been interested in snatching my daughter away from me?

REUBEN

 Mr. Carlson ... I'm not really snatching her away ...

WILLIAM

 Beverly, were you able to get to Wallmart and purchase those rifle shells I asked you to pick up?

BEVERLY

 I did, yes, would you like me to get the rifle out of the garage?

REUBEN

 You two are kidding right?

 BETHANY and ABIGAIL enter

BETHANY

 Kidding about what?

WILLIAM

 I haven't the slightest idea what he is talking about.

 WILLIAM moves behind REUBEN so that REUBEN can't see him. Makes various throat slashing motions while holding his finger up to his lips.

BETHANY

 Reuben, I apologize for whatever they were putting you through.

ABIGAIL

 But get used to it. So have you two kissed each other yet?

BETHANY / REUBEN

 (at the same time)
 NO !!

BEVERLY

 I think they do object too much. Reuben, how is your mother doing?

REUBEN

 She is doing great. (Beat) She is pregnant.

BEVERLY

 Wow!! I had no idea.

ABIGAIL

 Wow! She is so old !!

WILLIAM

 Abi !!

REUBEN

 It's ok Mr. Carlson. She is 42 ... I guess that's old ... no offense.

WILLIAM

 (Stage Whisper to BEVERLY)

 The rifle?

BEVERLY

 Stop it you two!! I think its cool. A younger brother or sister. You ready for that?

REUBEN

 I guess I'm going to have to be. Mr. And Mrs. Carlson, I was hoping to take Bethany out for some ice cream if it's ok with both of you.

WILLIAM

 Reuben, Mrs. Carlson and I like you and trust you with our daughter. Treat her well. You have our blessing.

BETHANY
> Thanks guys. Love ya !

WILLIAM
> Not too late Beth. Reuben, we will see you again soon. Don't be a stranger.

REUBEN and BETHANY Exit

Lights fade

Scene 4

Lights come up on REUBEN and BETHANY at the ice cream parlor.

REUBEN
> You have a great family.

BETHANY
> I like them.

REUBEN
> Does your dad really have a gun?

BETHANY
> Just treat me right and you have nothing to worry about.

REUBEN
> Who is older? You or Abi?

BETHANY
> I have her beat by two minutes.

REUBEN

Who do you like better? Your Mom or Dad?

BETHANY
> They are both great, but I would have to say my Dad. We have a good relationship. My mom is fine, but sometimes I just don't measure up to her expectations.

REUBEN
> And what is your favorite piece of scripture?

BETHANY
> I like Nephi's vision of the tree of life. What is up with the inquisition?

REUBEN
> Just want to know everything I can about you. Want to grow with you.

BETHANY
> Grow old with me?

REUBEN
> Well yeah. But also grow spiritually with you. I think Heavenly Father is happy with us when we want to learn more about him.

GEORGIA Enters

GEORGIA
> Reuben! Beth! How's it going? You guys on a date? I can leave you alone.

BETHANY
> No, not a date. Just ice cream. Sit down.

GEORGIA
> You guys are so cute together.

BETHANY

Thanks. He's a hottie.

All laugh

REUBEN
You only like me for my looks.

BETHANY
Your not that hot!

GEORGIA
Any big weekend plans?

REUBEN
Just hanging out. You?

GEORGIA
My brother gets home from his mission tomorrow. Big thing at church, hope you both are there

BETHANY
Wouldn't miss it.

GEORGIA
I'll leave you two in peace. Seriously, very happy that you two found each other. Treat him right Beth.

GEORGIA exits

REUBEN
I'm very happy Beth.

BETHANY
Me too. It's late. You should get me home.

REUBEN

 Maybe you'll actually let me kiss you goodnight?

BETHANY

 Lets hold off on that for now, ok? I know this is important to you, but I want our first kiss to be special.

REUBEN

 And your dad has that gun.

BETHANY

 Exactly.

BETHANY and REUBEN exit

Scene 5

As the lights come up BETHANY and REUBEN enter. He has just finished walking her home from their date and is saying goodnight. He is anxious to try to kiss her again, and BETHANY is still resolute that it is too early.

REUBEN

 Well this is it.

BETHANY

 Thanks for the ice cream.

Long drawn out pause as they each think of something to say.

REUBEN takes BETHANY's face in his hands. He hesitantly goes in to kiss BETHANY but she pulls away.

REUBEN

 (Defeated)

Ok. But I don't want to wait much longer. I mean ...

BETHANY

Its ok. Call me later so I can say goodnight. I'll be up for a bit.

REUBEN

I will.

They hug. REUBEN holds on a bit longer than BETHANY.

BETHANY Exits.

REUBEN gets a text message on his phone as he is leaving the stage. Text messages can be shown to the audience behind the actors on a large screen.

The text reads "R U Busy - GEORGIA" (The GEORGIA part would be for the audiences benefit as presumably REUBEN would know that it is from her.)

REUBEN responds with "Not Really"

GEORGIA responds "Want 2 hang out? Meet me 4 ice cream"

REUBEN responds "C U in 10"

Scene switches to inside the ice cream parlor. GEORGIA is sitting at a both and REUBEN enters.

GEORGIA

Hey. Where's Beth?

REUBEN

Dropped her off already.

GEORGIA
 So how are things going between you guys?

REUBEN
 I like her, pretty sure she likes me ...
 (Voice trails off)

GEORGIA
 But ...

REUBEN
 It's not a big deal. I went to kiss her goodnight and she didn't want anything to do with it. Again.

GEORGIA
 Bit of a red flag don't you think?

REUBEN
 What do you mean?

GEORGIA
 I just mean, dear innocent Reuben, that if someone who looked as good as you wanted to kiss me I wouldn't pull away. (Beat) It doesn't concern you that she won't kiss you?

REUBEN
 I'm not really concerned ... just ... well. Its not like I'm asking her to sleep with me.

GEORGIA
 Heavenly father wouldn't like that now would he.

REUBEN
 No, he wouldn't. I don't know what her problem is. (long beat) Would you really kiss me... if we were going out?

GEORGIA

Wouldn't you like to know. My lips are sealed. For now.

REUBEN

I'm glad you wanted to meet me here. Feels good to talk to someone about this. Can't really go out and tell the guys my girlfriend wont kiss me ... (trails off)

GEORGIA

What are you dong with Miss. Goody-too-shoes anyway?

REUBEN

I like her Georgia. She is a great person. I thought you two were friends.

GEORGIA

We are all friends Reuben. Just making conversation. Her and Abi are so perfect ...such good Mormons.

REUBEN

Aren't all Mormons good Mormons?

GEORGIA

Maybe you'll find out some of us aren't as good as others.

> *REUBEN's phone indicates he has a text message. The text messages read:*
>
> *"I'm heading to bed, can I call you?" (BETHANY)*
>
> *"I'll call you in a few ok, visiting with my mom"*
>
> *"It's cool. I'll see you at church. Goodnight"*
>
> *"OK, Goodnight, Beth."*

GEORGIA

> Are you ignoring me?

REUBEN

> No, that was my mom checking up on me.

GEORGIA

> Lame. It's ok though. I should be heading home.

REUBEN

> Thanks for letting me vent.

GEORGIA

> No problem. Just remember, I'm always here for you, OK.

REUBEN and GEORGIA Exit

Scene 6

An art classroom. LYRA and BETHANY are working on a project together. They are classmates but are not otherwise associated. The class has just ended and BETHANY and LYRA are cleaning up from their last project. They are the only two in the room.

BETHANY notices a picture that LYRA has drawn of a tree, with a locked door at the base of it. This would be projected behind the actors during the scene.

BETHANY

> (Pointing at the picture)
>
> That's so cool.

LYRA

> Thanks.

BETHANY

> What does it mean?

LYRA

> it is an existential view of humanity, from the point of view of Darwin, Freud and Mr. Rogers.

BETHANY

> Really?

LYRA

> No, it's a picture of a locked door in a tree.

BETHANY

> And what is behind the door?

LYRA

> I don't know. I haven't found the key yet. What are you working on there?

BETHANY

> I'm not much of an artist. I think its a tree, or a mountain. Perhaps it's a gopher? Lets go with gopher.

LYRA

> Your funny.

BETHANY

> So are you. I'm Bethany. But my friends call me Beth.

LYRA

> Nice to meet you Beth. I'm Lyra. You have amazing eyes.

BETHANY

> Thanks. I'm surprised we haven't met before. Have you

always gone to this school?

LYRA

No, I transferred here about a month ago. My parents broke up, mom needed a fresh start and here I am.

BETHANY

I'm sorry ...

LYRA

My mom wanted a challenge. Nothing like being a single mom in Provo.

BETHANY

Where do you go to church?

LYRA

We don't.

BETHANY

Oh, you should come to mine. It's a nice ward, friendly people ...

LYRA

No ... Beth its not that we haven't found a church yet. We don't go to any church. Mormon or otherwise.

BETHANY

Oh.

LYRA

If you need to stop talking to me or something I totally get that. I've been invited to a couple churches by a couple different Mormons ... they don't usually talk to me much after I tell them that my mom and I don't believe in organized religion.

BETHANY

Oh.

LYRA

Yeah. So ... do you still want to be friends. Cause you seem like a nice person and I think we would get along. But if it would be breaking a commandment or something I get that.

BETHANY

No, It's cool. But what do you have against Mormons?

LYRA

Beth, if there is a God, why would he only care about one group of people? If there is a God, and I'm not sure there is, I believe he or she is for everyone. Religion just makes things difficult. It controls people and stuff. It tells you that who you are is not good enough ... you have to be better and be someone that people are comfortable with. I'm not sure I make people comfortable. Especially Mormon people. But that's just me.

BETHANY

You don't make me uncomfortable. Maybe you should...
 (Laughs)
But it would be cool to be friends.

LYRA

Are you sure about that? I Don't want you getting kicked out of your church.

REUBEN Enters

REUBEN

Hey Beth.

BETHANY

Hey Reuben. This is my new friend Lyra. Lyra, this is my boyfriend Reuben.

LYRA

 It's nice to meet you Reuben. Have you two been together long?

REUBEN

 No, not really. We kind of just got together.

LYRA

 I should get going. Nice to meet both of you.

 LYRA Exits.

REUBEN

 You've made a friend.

BETHANY

 Yeah, she seems nice.

REUBEN

 I haven't seen her around.

BETHANY

 She's new.

REUBEN

 Cool. Did you invite her to go to church?

BETHANY

 She's not a member.

REUBEN

 I didn't know non-members lived in Provo ... I'm kidding. Invite her this Sunday.

BETHANY

 I'm not sure she would be up for it. She doesn't believe in church ...or God.

REUBEN

Beth, it's important to spread the gospel. Invite her anyways, you never know.

BETHANY
Ok, I'll ask her, but don't get your hopes up. Call me later ok. I have to get to class.

REUBEN
Later

REUBEN and BETHANY Exit

Scene 7

Lights come up on BETHANY and ABIGAIL in their room.

ABIGAIL
Please tell me you've kissed him.

BETHANY
If I say yes will you stop asking me?

ABIGAIL
Did you?

BETHANY
No.

ABIGAIL
(Exasperated)
You'll lose him.

BETHANY
I'm Not sure that concerns me right now.

ABIGAIL

Everything ok with you guys?

BETHANY

Is it weird that I don't want to kiss him?

ABIGAIL

Why not? He's your boyfriend. Most people kiss when they date. What are you concerned about?

BETHANY

To be honest I'm not sure. I just don't get excited thinking about him. When we hug, I don't feel like kissing him. I just want him to let me go. He always tries to kiss me though.

ABIGAIL

Well, you have a right to tell him no. But Beth, it would be ok if he kissed you. He wants to kiss you. Most girls our age want a boy who is excited to kiss them. I think your looking a gift horse in the mouth here

Doorbell rings.

BETHANY

That is probably him. He was on his way over. Can you go get it? I need a moment.

ABIGAIL

Sure. Just remember, you have a good thing here. Don't mess it up ...

ABIGAIL exits to answer the door.

ABIGAIL
(from offstage)
Bethany, its Reuben. Want me to send him up?

BETHANY

Yeah, send him up. And no listening outside the door.

REUBEN Enters

REUBEN
> Hi Beth.

BETHANY
> Hey Reuben. How's life?

REUBEN
> I need to talk to you.

BETHANY
> Yeah, what's going on?

REUBEN
> Don't worry its nothing. I just want to talk about why you wont kiss me. You treat me more like a good friend than a boyfriend.

BETHANY
> We'll, you are a good friend. I just need some time. Kissing is so intimate.

REUBEN
> Boyfriends and girlfriends kiss ... and some even go farther than that. I mean, lots of people our age have already slept together and ...

BETHANY
> (suspiciously)
> Is this why you came over? To talk me into sleeping with you?

REUBEN
> (Defensively)
> No, not at all. I am fine waiting until we are married

to ...you know ... have sex.

BETHANY
 (exhausted. Tired of talking about
 this.)
What happens when I kiss you? Will you want more? Second base, third base ... how long before you want to hit a home run Reuben?

REUBEN
 (getting angry)
This was a mistake. Georgia warned me about red flags

BETHANY
 (getting angry)
You have been discussing this with Georgia? Really?

REUBEN
We met after I dropped you off, she is a friend and we were just chatting ...

BETHANY
Wait, I texted you and you said you were talking to your mother. So what is it Reuben? Were you lying to me?

REUBEN
Never mind Beth. If you don't want to kiss or be physical at all I'll just have to live with it.

BETHANY
 (After a pause to compose herself)
You want me to kiss you? Will that help you realize that I care for you and want you in my life?

REUBEN
 (Sheepishly)
Well, would it be the end of the world? Just one kiss,

and then its not an issue anymore. OK ?

BETHANY considers it for a minute. She then walks over to REUBEN and they kiss after a tense moment. It is an awkward kiss and BETHANY breaks it off before REUBEN does.

REUBEN goes in to kiss BETHANY again and BETHANY tentatively allows him to kiss her. Just as this happens ABIGAIL walks in and witnesses the second kiss.

ABIGAIL
 Busted!!

BETHANY
 (exasperated)
 Does no one knock in this house?

ABIGAIL
 Its my room too. Be nice or I tell Mom and Dad you and Reuben were kissing in your room!

REUBEN
 Really Abi? Blackmail?

BETHANY
 Its fine Reuben.
 (Giggling)
 Its actually pretty funny.

ABIGAIL
 (Laughing)
 Don't worry Reuben. Your secret is safe with me.

REUBEN
 OK. Well, I'm going to head home. Lets all get together soon.

ABIGAIL
 Don't be a stranger Reuben.

BETHANY
 Yeah, I'll see you soon.
 (To REUBEN)
 Lets keep this between you and I OK? Don't go bragging to your friends or anything. I'll talk to Abigail. Wont be a problem.

REUBEN
 (To BETHANY)
 Of Course. See you later.

 REUBEN Exits

ABIGAIL
 Sooooo Details

BETHANY
 I don't want to talk about it.

ABIGAIL
 That good?

BETHANY
 That bad.

ABIGAIL
 Oh no. Is he a bad kisser?

BETHANY
 I'm sure his technique is fine. Abi, I didn't feel anything. Nothing. It was mechanical and frankly kind of gross.

ABBGAIL
 It was the first kiss for you guys. And it didn't seem like a magical moment or anything ...

BETHANY

 He kind of manipulated me into it.

ABIGAIL

 You guys going to be ok?

BETHANY

 Yeah, I think so. Just wasn't the best kiss.

Text message from REUBEN

"That was awesome. Talk soon" (REUBEN)

"Yeah, talk soon. C ya" (BETHANY)

ABIGAIL

 Was that him?

BETHANY

 Yeah, he actually thought it was pretty awesome.

ABIGAIL

 Boys ... yet we love them.

BETHANY

 (Distracted)
 yeah, we love them

ABIGAIL

 What is it?

BETHANY

 Nothing, nothing at all. Want to go to the mall or something? I need to get out of the house.

ABIGAIL

 Sounds good ... Beth, everything will be ok.

BETHANY
> Yeah, it will. I'm sure of it.

ABIGAIL and BETHANY Exit

Scene 8

BETHANY and Abi are hanging out at the mall when she receives a text from LYRA.

"Hi. Its LYRA. Are you busy?"

"Just hanging out with my sister. Meet us at the mall"

"I'm already here. Small world."

"We r at food court. C U in 5"

ABIGAIL
> Who was that?

BETHANY
> My new friend, Lyra. She is that new girl at school, pretty one. I met her the other day.

ABIGAIL
> Where does she go to church?

BETHANY
> She doesn't. Not sure she even believes in God to be honest with you.

ABIGAIL
> (Hesitantly)
> You sure that this is someone you should be hanging out with?

BETHANY

 I thought about that when I first met her. But maybe she is my mission. Or something ...

ABIGAIL

 Just be careful ok.

BETHANY

 I'll be fine Abi. She is a real sweetheart.

 LYRA Enters

BETHANY

 Lyra, over here.

LYRA

 Beth ! Good to see you again.

BETHANY

 This is my twin sister Abigail.

ABIGAIL

 Call me Abi.

LYRA

 Sounds good Abi.

BETHANY

 What are you doing at the mall?

LYRA

 (In utter disbelief that BETHANY asked such an obvious question.)
 Thought I would do some ... shopping.

ABIGAIL

 (trying not to laugh)
 Really ... at the mall?

BETHANY

Laugh it up you two!

LYRA

I'm sorry sweetie, that was just way too easy.

ABIGAIL s phone gets a text. She looks at it and rolls her eyes. (nothing needs to be shown on the screen)

ABIGAIL

Well, that was Mom. Apparently its my night to help with dinner.

LYRA

You guy's need to go?

ABIGAIL

Well, I do. But if you want to give Beth a ride home ... she doesn't have to be home right away.

BETHANY

Oh, you don't have to ...

LYRA

(interrupting)

I'd love to. It would be cool to hang out. You can help me pick out some jeans.

BETHANY

You sure?

LYRA

All good.

ABIGAIL

Well, it was great to meet you Lyra. See you at home Beth.

ABIGAIL exits

Scene continues with BETHANY and LYRA sitting in food court.

LYRA

 She is pretty cool.

BETHANY

 We are close. I didn't ask, do you have any brothers or sisters?

LYRA

 Nope, I'm an only.

BETHANY

 And your parents are divorced?

LYRA

 They were never married. My mom met a guy, they were never really serious. Nine months later I came along. I don't even really know my dad.

BETHANY

 I'm sorry.

LYRA

 Why? My mom taught me to be strong in who I am. And don't depend on guys for my self worth. Which is actually pretty easy ...
 (Trails off)

BETHANY

 Why is that so easy?

LYRA

 Beth, I'm a lesbian.

Long uncomfortable beat

BETHANY

OH.

LYRA

I know that isn't overly acceptable here in Salt Lake, but I wanted you to know. Again, if you can't be my friend I understand and ...

BETHANY
(Interrupting too quickly)
It's fine

Another uncomfortable beat

LYRA

Are you cool with that?

BETHANY

I don't know yet. But I want to be your friend.

LYRA

That is really cool Beth. Thank you. Its been hard finding friends.

BETHANY

How did you find out? I mean, when did you know?

LYRA
(Thoughtfully)
You know its funny. I can't think of one moment when I haven't been Gay. Men just never really did it for me. I've kissed a few guys ... it was mechanical and just there.

BETHANY

Mechanical ...
(beat)
Was it also kind of gross.

LYRA

　　Yes !! But it wasn't just that ... I started realizing that a man wouldn't make me happy. I wasn't born to be with a guy. I tried to just be single for a while ... but then I started to date girls.

BETHANY

　　So when you look at a girl, what do you think? I mean, how does it make you feel?

LYRA

　　Probably like when you look at your boyfriend. Randall? Robert?

BETHANY

　　Reuben

LYRA

　　Reuben, right. You know that first time you kissed him and felt the sparks, the magic? That is what it was like for me. Except it was with a girl.

BETHANY

　　　　　(long beat.)
　　It wasn't like that with Reuben. We just had our first kiss today.

LYRA

　　Uh oh.

BETHANY

　　It wasn't horrible. I just didn't feel anything.

LYRA

　　Don't go thinking your Gay, just because this one didn't make you feel all weak-in-the-knees.

BETHANY

BETHANY
 I'm not gay.

LYRA
 Of course your not.

BETHANY
 It was just one kiss.

LYRA
 Do you like him?

BETHANY
 We've been friends forever. It is the natural thing to
 get together. My church teaches that it is good to get
 married ... its actually kind of expected.

LYRA
 Sweetie, you didn't answer the question.

BETHANY
 I am just not sure that I feel anything for him. At
 least not what I should be feeling for him.

LYRA
 Well, I'm not going to tell you what to do. I'm sure
 it will work out just fine.

BETHANY
 He is a good guy. I just couldn't break his heart.

LYRA
 Yeah, wouldn't want to do that.

 BETHANY's phone indicates text message.

 BETHANY checks her phone and rolls her eyes.

LYRA

Your Mom?

BETHANY

 No, Reuben.

LYRA

 Beth, we have kinda just met and I don't want to interfere but that isn't the kind of look that a girl should make when her boyfriend texts her.

BETHANY

 He wants me to hang out tonight with him and Georgia. There is this party ... probably pretty lame.

LYRA

 Georgia?

BETHANY

 Another friend of mine. She is kinda a friend of Reuben's as well.

LYRA

 Your boyfriend's girlfriend?

BETHANY

 Want to come? Meet some of my friends?

LYRA

 Are they all as cool as you?

BETHANY

 Cooler.

LYRA

 Then its a date. And Beth, don't be afraid of who you are ok?

BETHANY

 I'm not ... wait, what do you mean?

LYRA

Nothing. Just a figure of speech. Do you need to go home? Its already 530.

BETHANY

I'll let my parents know I'm eating out tonight. Lets go get those jeans you wanted.

LYRA

Sounds great.

LYRA and BETHANY Exit.

Scene 9

BETHANY and LYRA are walking to the party. They are just outside the front door.

BETHANY

Lyra, before we go in ...
 (hesitant)
Don't mention anything about being Gay.

LYRA

I'm not going to lie about who I am to these people.

BETHANY

But they are my friends. They're good people, its just that they are also Mormons.

LYRA

Your Mormon. You seem to be very understanding.

BETHANY

Just don't mention it tonight ok? I'm not ashamed or anything ... but I want them to like you as much as I do.

LYRA
> (resigned)
>
> OK. If it helps, I will keep it a secret tonight.

LYRA and BETHANY enter the party and are greeted by REUBEN, GEORGIA and ABIGAIL who have already arrived.

REUBEN
> Bethany!

BETHANY
> Hey. Everybody, this is my friend Lyra. Lyra this is everybody.

GEORGIA
> (Introducing herself)
>
> I'm Georgia. Its nice to meet you. I have seen you around school.

LYRA
> Thanks. Its nice to meet you too.

ABIGAIL
> I'm glad you could come Lyra.

LYRA
> So, what is the big celebration. Is it someone's birthday or something?

GEORGIA
> No, my brother got back from his mission. He should be here a bit later.

LYRA
 Cool!

GEORGIA
 Can I get you something to drink?

LYRA
 Red Wine?

> *REUBEN, GEORGIA and ABIGAIL laugh. BETHANY shoots them all a look.*

LYRA
 It isn't that kind of party?

GEORGIA
 Its ok. We don't really go for Alcohol.

LYRA
 I'm sorry ... I didn't mean to offend anyone ...

ABIGAIL
 Its all good.

GEORGIA
 Yeah, its no big deal. We have punch, soda ...

LYRA
 I'm good for now. Thanks.

REUBEN
 Beth, come help me in the kitchen.

GEORGIA
 Don't be long you two, or I'm coming in there after you!

> *REUBEN and BETHANY Exit to Kitchen*

ABIGAIL
 (to LYRA)
 Beth told me you just moved here. Where are you from?

LYRA

 I've moved a bit in the last little while. Recently I lived in Boise.

ABIGAIL

 And why did you pick Provo?

LYRA

 My mom got a promotion and a transfer.

ABIGAIL

 And your Dad?

LYRA

 Its kind of just my mom and me. I never knew my biological father.

ABIGAIL

 That is so sad.

LYRA

 Its kind of all I've known so don't feel too sorry for me.

GEORGIA

 So, Lyra, any guys at school that you have your eye on?

 Just as GEORGIA says this REUBEN and BETHANY enter. It is obvious to everyone that they have been fighting.

 BETHANY hears GEORGIA ask about Guys and quickly "saves" LYRA from having to answer.

BETHANY

 (Angry)
> Can we give Lyra a break? Stop with the inquisition?

GEORGIA
> Beth, we were just being friendly. Trying to learn about your new friend.

BETHANY
> Just stop with the personal questions.

ABIGAIL
> Beth calm down. Lets put on some music or something.
>> (To GEORGIA)
> When is your brother supposed to get here?

GEORGIA
> Anytime now.
>> (Coldly)

GEORGIA
> Lyra, I'm sorry if I offended you.

LYRA
> Its ok.
>> (to BETHANY)
> Want to go for a walk around the block or something? You seem upset.

BETHANY
>> (to LYRA)
> Not a bad idea.
>> (To everyone else)
> I'm sorry for my outburst. I'm going to go for a walk with Lyra. Be back in a bit.

> *Scene switches to LYRA and BETHANY walking. They sit down on a bench.*

LYRA
> I appreciate you thinking about me, but you didn't have

to take it out on your friends.

BETHANY

They make me angry. I'm sorry I embarrassed you.

> *LYRA takes BETHANY's hand. BETHANY notices and makes a half-hearted attempt to pull away. But then takes LYRA's hand in hers.*

LYRA

You've been so kind to me.

BETHANY

Your different than my other friends. You just don't seem to care what people think about you. It really is refreshing.

LYRA

I don't understand why people hide who they are. I've never had to worry about a religion telling me what is right or wrong.

> *Long pause as BETHANY decides how to respond to this. She changes the subject.*

BETHANY

So they asked you if there is a boy at school you are interested in. Let me ask you, is there a girl you are interested in?

LYRA

Well, as a rule I don't find straight women particularly attractive. I haven't found another gay woman in this city yet.

BETHANY

Well, if you ever get tired of looking for one, I know a lot of boys ...

LYRA

Thanks but no thanks...
> (hesitantly)

Beth, its none of my business, but what is up with you and Reuben. You don't look like your in love.

BETHANY

We only just started dating.

LYRA

You don't have to talk about it if you don't want to.

BETHANY

He tried to kiss me again. ... Lyra, I don't feel a thing for him when he kissed me. Nothing.

LYRA

What happened?

BETHANY

He just made some stupid joke about getting me alone, and then put his arms around me and kissed me. I turned my face so he only got my cheek. We started arguing. We knew it would be awkward if we continued to fight in the kitchen. We just kind of decided to forget about it tonight.

LYRA
> (Touches BETHANY's face)

I'm sorry.

BETHANY
> (After a long pause)

We should get back.

BETHANY's phone indicates a text message

"Do you guys want some junk food" (ABIGAIL)

"I think were fine"

"Text if you change your mind"

LYRA

 I need more friends. Then I would get as many text messages as you.

BETHANY

 Abi is heading out to buy some junk food. We should get back.

 Scene shifts to GEORGIA and REUBEN alone in the house.

GEORGIA

 So what was that all about in the kitchen?

REUBEN

 We had a disagreement.

GEORGIA

 Want to talk about it?

REUBEN

 It was a stupid fight. No big deal.

 GEORGIA crosses and sits next to REUBEN.

GEORGIA

 Are you happy?

REUBEN

 I'm happy. I just don't know what her problem is.

GEORGIA

 (Flirty)
 You know that I wouldn't have a problem kissing you.

REUBEN

> Georgia ... I'm with Beth.

GEORGIA

> I just think you could do so much better. You deserve a girl who wants to be with you.

REUBEN

> I'm pretty sure she wants to be with me.

GEORGIA

> Are you?

REUBEN

> I don't know.

GEORGIA

> Reuben, come here.

REUBEN slowly decides to sit closer to GEORGIA

She puts her hand on his leg and they stare at each other for a long minute.

GEORGIA

> Do you want to kiss me?

REUBEN

> I don't want to hurt Beth.

GEORGIA

> She wont know.

REUBEN

> you promise?

GEORGIA

> Come here

GEORGIA and REUBEN slowly kiss each other. Then

they kiss again more passionately.

LYRA and BETHANY walk in the front door and catch REUBEN and GEORGIA kissing.

BETHANY
 (unbelieving)
 OH MY GOD !

REUBEN
 Beth !!!
 (Quickly crossing to BETHANY)

LYRA
 Don't Reuben. What the hell?
 (To BETHANY)
 Let's get you out of here.

BETHANY
 I can't believe you.

REUBEN
 I don't want to hurt you!

GEORGIA
 Let her go Reuben.

LYRA
 (To BETHANY)
 Let's go.

BETHANY and LYRA exit

GEORGIA
 Reuben, I know you didn't want her to find out.

REUBEN
 I'm not sure what to do.

GEORGIA
> My brother will be here in a few. Enjoy the party and we will all work it out tomorrow. I'm sorry about all this.

> *REUBEN tries sending a text to BETHANY which shows up on the screen behind them.*

> *"I'm sorry. It was a mistake"*

Scene 10

BETHANY and LYRA are outside of BETHANY's house, sitting in LYRA's car. BETHANY has been crying and is beside herself. LYRA is trying to console her.

BETHANY
> (Crying)
> I just can't believe him ...

LYRA
> Sweetie I'm so sorry.

BETHANY
> Why didn't he tell me it was so important to him.

LYRA
> That's not what you want.

BETHANY
> I just want to be happy.

LYRA
> You told me you felt nothing for him.

BETHANY
> I still see him with her. The two of them kissing each

 other ... first chance he had with her he took it.

LYRA

 Beth, maybe its for the best. There might have been a reason why you don't feel anything for him right?

BETHANY

 He did kind of suck as a kisser.

LYRA

 I think its more than that.

BETHANY

 What do you mean?

LYRA

 Be true to yourself and who you are. That's all I'm saying.

BETHANY

 Thanks for driving me home.

LYRA

 Why don't you come over to my place for a while. You don't want to face your family right now.

BETHANY

 Yeah, I would like that.

LYRA

 Cool. We'll do each others hair ... eat ice cream.

BETHANY

 Don't make me laugh! I don't want to laugh right now.

LYRA

 Come on, lets have fun tonight.

 BETHANY receives REUBEN's text message.

"I'm sorry, it was a mistake"

responds

"We'll talk tomorrow."

Scene shifts to LYRA and BETHANY at LYRA's house.

LYRA
 Just try it!

BETHANY
 I can't.

LYRA
 One sip and then I will leave you alone.

BETHANY
 (Sniffing the wine)
 Smells like grape juice ...

LYRA
 You are so cute. Its red wine, something my mom leaves in the fridge. It is supposed to help you calm down.

BETHANY
 (putting the wine aside)
 Does your mother let you drink?

LYRA
 (Laughing)
 I never have more than one small glass, usually with dinner.

BETHANY
 Your Mom sounds cool.

LYRA

 I like her.
 (hesitantly changing the subject)
 So what are you and I going to do about Reuben.

BETHANY

 Ahhhh !! I had almost forgotten.

LYRA

 (Touching BETHANY's face)
 Can we string him up? Cut something off?

BETHANY

 (Laughing embarrassed)
 LYRA !!!

LYRA

 I'm serious. Teach him to cheat on you.

BETHANY

 (Takes a long pause)
 Lyra, is it wrong that I'm kinda getting over it?

LYRA

 No. I've told you be true to yourself.

BETHANY

 You keep saying that.

LYRA

 Because you need to listen.

BETHANY

 I know who I am.

LYRA

 Who are you?

BETHANY

 I'm Bethany.

LYRA

 And ...

BETHANY

 I'm a Mormon?

LYRA

 Is that a question?

BETHANY

 What do you want me to say?

LYRA

 Why don't you enjoy kissing Reuben?

BETHANY

 I just don't feel anything for him.

LYRA

 How about boy's in general?

BETHANY

 (suddenly realizing what LYRA is getting at)

 You think I'm gay?

LYRA

 Are you?

BETHANY

 I don't think so.

LYRA

 Does it bother you that I ask?

BETHANY

No ... but I'm pretty sure I'm not gay.

> *LYRA looks at BETHANY for a long pause and then finally breaks the ice.*

LYRA

There has to be a reason why Reuben doesn't do it for you.

BETHANY

I can't' explain it to you either.

LYRA

Have you ever thought about girls?

BETHANY

(Thoughtfully)

I would be lying if I said I hadn't thought about it. I find myself checking out a girl as she walks by, or wondering what she looks like topless ... I can't believe I'm telling you this.

LYRA

Beth, ... I've thought about you a lot since we met.

BETHANY

(uncomfortably)

In what way.

LYRA

I know your with Reuben. I don't understand why you stay with him.

BETHANY

(repeating herself)

In what way? Do you think of me?

LYRA

Let me show you.

> *LYRA takes BETHANY's hand and pulls her towards her. BETHANY initially tries to pull away but LYRA gently pulls her back. She meets BETHANY's eyes and slowly kisses her.*

BETHANY
 Lyra ...

LYRA
 Was that anything like kissing Reuben?

BETHANY
 Lyra ... I can't be kissing you.

LYRA
 Because you don't want to?

BETHANY
 No.

LYRA
 Do you want me to kiss you again?

BETHANY
 (Long uncomfortable pause)
 Yes.

> *They kiss again. This time much longer and more passionately.*

> *During the kiss LYRA starts to touch BETHANY's breast. BETHANY pulls away.*

LYRA
 I'm sorry, I went too far.

BETHANY
 Yeah, you did.

LYRA

> There is nothing wrong with what we did.

BETHANY

> I'm ok. I Just need to get home.

LYRA

> I understand. I'll drive you home, and I'll call you tomorrow. Just promise me you will think about who you truly are tonight.

BETHANY

> Kissing you was much better than kissing Reuben.

LYRA

> (laughing)
> Lets get you home.

> *LYRA and BETHANY exit.*

Scene 11

BETHANY's house. WILLIAM and BETHANY are sitting in the front room as BETHANY enters sheepishly. She is not excited about taking to her parents.

WILLIAM

> Beth, Your home early.

BEVERLY

> I thought you were staying for the party.

BETHANY

Yeah, well ... it ended shortly.

WILLIAM
Where is Abi? You two didn't come back together?

BETHANY
No, I got a ride with my new friend Lyra.

WILLIAM
Lyra? Did you meet her at church?

BETHANY
(getting annoyed with questions)
School.

BEVERLY
Beth. Is there something wrong?

BETHANY
No ... nothing's wrong. I'm going to bed. Goodnight.

BETHANY exits

WILLIAM
That isn't like her.

BEVERLY
Let's assume that she had a fight with Reuben or something.

WILLIAM
Still ... I've gotten used to her talking to us about things.

BEVERLY
She's 17. We're going to have to get used to her ignoring us.

ABIGAIL enters. She is also sheepish about

talking to her parents.

WILLIAM
 Must have been a brutal party. Someone else just got home early.

ABIGAIL
 yeah, hi. ... is Beth home?

WILLIAM
 Upstairs, tell her we said hi.

BEVERLY
 What is going on?

ABIGAIL
 Nothing ... she and Reuben had a fight or something.

WILLIAM
 If its something we need to know, would you please fill us in?

ABIGAIL
 I will, but I'm sure its just some teen drama.

 ABIGAIL exits.

 Scene shifts to ABIGAIL and BETHANY's bedroom. BETHANY is sitting on her bed.

 ABIGAIL enters.

ABIGAIL
 So ...

BETHANY
 I don't want to talk about it.

ABIGAIL

I understand. Mom and Dad are a bit concerned.

BETHANY
What happened at the party? After I left ...

ABIGAIL
I got back and asked where you were. They said you left suddenly with Lyra.

BETHANY
That's all?

ABIGAIL
Yeah. I stayed for a little bit, but I was worried about you so I came home early.

BETHANY
(in disbelief)
He didn't tell you what I walked in on?

ABIGAIL
No.

BETHANY
I walked in on him and Georgia making out.

ABIGAIL
In front of you?

BETHANY
No, Lyra and I went for a walk around the block. When we came home they were kissing each other ...

ABIGAIL
He didn't tell me that. So you two are broken up?

BETHANY

> (Hesitates)
> I'm sure its only a matter of time.

ABIGAIL
> There is something else you aren't telling me.

BETHANY
> (very hesitantly)
> Something happened.

ABIGAIL
> what ... ?

BETHANY
> Something ... different.

ABIGAIL
> Oh God, you didn't go back and beat him up did you?

BETHANY
> No. I kissed Lyra.

ABIGAIL
> On purpose?

BETHANY
> Of course on purpose. Abi, you can't tell anyone ok?

ABIGAIL
> You kissed Lyra?

BETHANY
> I was mad at Reuben. At first she kissed me, but pretty soon I was kissing her back.

ABIGAIL
> You know what the scriptures say about ...

BETHANY
(interrupting)
I'm not Gay.

ABIGAIL
Yeah, but ...

BETHANY
It was a mistake to tell you anything.

ABIGAIL
(gently)
How did it make you feel? Kissing her.

BETHANY
I liked it.

ABIGAIL
This could really hurt your reputation at school and at church.

BETHANY
I trust her.

ABIGAIL
What about Reuben?

BETHANY
I will break up with him.

ABIGAIL
Is he going to date Georgia now?

BETHANY
I suppose. They deserve each other.

ABIGAIL
Want to get out of here, get some junk food or something?

BETHANY
 I would like that. Thanks for listening.

 BETHANY's cell phone rings. Another text message on big screen.

 "Can we talk" (REUBEN)

 "I'm out with Abi"

 "Are u mad"

 "yes"

 "I'm sorry"

 "c u tomorrow"

 End of Act 1

ACT 2

Scene 1

Next day

A school hallway. LYRA and BETHANY are walking to class and GEORGIA approaches them.

GEORGIA
 Beth, can we talk?

LYRA
 Why would she want to talk to you?

GEORGIA
 Listen, I don't remember your name, but Beth and I have been friends a lot longer than you have known her so just mind your own business.

BETHANY
 Don't talk to her that way. If it's about Reuben we are pretty much done so he is all yours.

GEORGIA
 (Surprised)
 You don't have to break up with him. We just got a

little carried away.

LYRA

 Trust me, she doesn't feel anything for Reuben.

BETHANY

 Lyra ...

LYRA

 Oh, is this one of those big secrets?

GEORGIA

 What does that mean?

BETHANY

 Nothing, it doesn't mean anything.

LYRA

 It means that maybe Beth has found someone else.

BETHANY

 Lyra, that is enough !!

GEORGIA

 I don't understand any of this. I hope you and Reuben can work it out.

 GEORGIA exits

BETHANY

 (angry)
 (To LYRA)
Ok, that needs to stop right now!

LYRA

 Ok, I get it. You don't want anyone to know you cheated on your boyfriend.

BETHANY

Its not just that. You are Gay. And that is not cool with most people here.

LYRA
Ok !! Honestly Beth, you are so afraid of being who you are ... its actually pretty pathetic.

BETHANY
Just drop it.

REUBEN enters and approaches BETHANY.

REUBEN
Hi Beth. Lyra.

LYRA
This is where I find somewhere else to be.
(To BETHANY)
Call me later.

BETHANY
(To LYRA)
I will. I'm sorry.

LYRA Exits

REUBEN
What was that all about.

BETHANY
That is really none of your business.

REUBEN
Are you still mad at me?

BETHANY
Surprisingly I haven't gotten over you cheating on me. I don't think there is any point in us trying to stay together.

REUBEN
(sad)
I don't want to lose you.

BETHANY
You weren't concerned about that last night.

REUBEN
I was thinking of you the whole time.

BETHANY
(angry)
No Reuben. You weren't.

REUBEN
(pathetically)
I want to work this out.

BETHANY
I don't.

REUBEN
(resigned)
Fine. I'm sorry it ended this way. I hope we can all still be friends.

BETHANY
Whatever. I'm going to find Lyra. We were in the middle of a conversation when you interrupted.

BETHANY Exits

REUBEN texts on his phone for the big screen

"Lets hang out" (To GEORGIA)

" U ok? "

"yeah, guess so. Better when I get to see u again"

" can't wait. c u tonight"

Scene 2

Interior of BETHANY's house. WILLIAM and BEVERLY sitting in the family room.

BETHANY enters and tries to go straight upstairs.

WILLIAM interrupts her

WILLIAM
　No !

BETHANY
　No what.

WILLIAM
　No, you don't get to go upstairs without talking to us.

BETHANY
　I don't really want to.

BEVERLY
　What is going on with you? You've been in a horrible mood these last few days.

BETHANY
　　　(frustrated but resigned)
　Reuben and I broke up.

WILLIAM
　After I told him about the gun?

BETHANY
 See, this is why I don't want to talk with you guys,
 you don't take anything seriously.

BEVERLY
 Beth, what your father is trying to say is that we are
 very sorry.

WILLIAM
 Yeah, we are. Come on Beth, this is your first love but
 it wont be your last. Give it some time, but in the
 meantime it would be great if you didn't take your
 frustrations out on your family.

BETHANY
 (apologetically)
 Your right. I'll work on my attitude.

WILLIAM
 Thanks Beth.

BEVERLY
 Are you home for the night?

 BETHANY's phone indicates another text message

 up on the screen

 "I need to see you tonight" (LYRA)

 "OK, but we just talk, or I'm not coming over"

 "I promise ... just need to see u"

 "all right, I'll c u soon"

BETHANY
 Actually, I was just invited over to Lyra's house.

BEVERLY
 Don't be too late tonight.

BETHANY STARTS TO EXIT.

BETHANY
 I'm glad I can talk to you.

WILLIAM
 Anytime ! Our family doesn't keep secrets.

 BETHANY Exits

WILLIAM
 This parenting thing is pretty easy.

BEVERLY
 Do you think she tells us everything?

WILLIAM
 Not for a minute, but I think we hear about the important stuff, and that is what really matters.

 Scene shifts to BETHANY and ABIGAIL's bedroom

 ABIGAIL is already in the room as BETHANY enters

BETHANY
 Hey

ABIGAIL
 Hey

BETHANY
 (is getting ready to go out)
 Can I borrow your new shirt. The one you bought the other day?

ABIGAIL

Sure. Do you have a date or something?

BETHANY

No, just going over to Lyra's.

ABIGAIL

Hmmmm

BETHANY

Its not like that.

ABIGAIL

I hope its that simple. I think your playing with fire.

I saw Reuben at school today. He is pretty upset.

BETHANY

I am not all that concerned about Reuben. He has Georgia to kiss his wounds.

ABIGAIL

And you have Lyra?

BETHANY
(Angry)
You know what, I don't really need to borrow your shirt. Its kind of frumpy anyways.

ABIGAIL

Whoa calm down. Don't take it out on the shirt. Your making him feel 100 percent responsible, as if you did nothing wrong.

BETHANY

 I really don't care if he feels horrible or not.

ABIGAIL

Ok. Just my two cents. Can I give you a ride to

> Lyra's house?

BETHANY
> That would actually be pretty cool of you. Thanks.

ABIGAIL
> Let me know when your ready. The frumpy shirt is in my closet if you still want to wear it.

BETHANY
> (laughing)
> Its not frumpy. Thanks.

ABIGAIL
> No worries. I'll be downstairs.

> *ABIGAIL exits*

> *BETHANY's phone indicates a text*

> *"Are you still coming?" (LYRA)*

> *"On my way, just getting dressed"*

> *"Sexy. Just kidding. See you in a few"*

> *Lights go down*

Scene 3

> *LYRA's house. BETHANY and LYRA are sitting on the couch eating junk food. LYRA has a red wine. BETHANY has a sprite (7-up).*

LYRA
> Sure you wont have any wine?

BETHANY

I didn't have any last time.

LYRA

Oh yeah.

BETHANY

So what was the real reason you invited me over here?

LYRA

I want to clear the air. I want to be your friend and apologize for everything that has happened.

BETHANY

What are you apologizing for?

LYRA

For taking advantage of you. For making the situation worse. Reuben must have freaked out when you told him about me.

BETHANY

I haven't told anyone about you.

LYRA
(taken back)
Really.

BETHANY

I just don't think any of my friends would understand ... they would think I am a lesbian or something.

LYRA
(sarcastically)
Wouldn't want that.

BETHANY

If your going to get angry, I'll just call my sister and have her pick me up.
> (Goes to get up

LYRA
> (stopping her)

I'm sorry. I don't want you to go. But Beth, didn't you feel anything when we kissed?

BETHANY
> (trying to avoid the conversation)

Can we watch a movie or something?

LYRA

I deserve to know if you felt anything or not. Since that kiss you are all I think about ...

BETHANY

Your creeping me out a bit.

LYRA
> (trying to explain)

I want you to be who you are, and realize that it is wonderful and ok to have feelings for someone like me.

BETHANY

Lyra, you can't go around talking about me or making little comments. Once people find out your gay and associate me and you it wont be long until they are making assumptions about our relationship.

LYRA

What assumptions are those? That we like each other? That we enjoy spending time together? That we are more than friends?

BETHANY

But we aren't. We aren't more than friends.

LYRA

 I would like to be.

BETHANY

 Isn't there a gay woman in Provo you would find a little bit more attractive than me?

LYRA

 I could try to find someone else, but when you have found someone you know you are meant to be with ...

 And since you dumped Reuben you are totally available.

BETHANY

 I'm not gay

LYRA

 How often do you think about kissing me?

BETHANY

 Lyra ... I don't want to answer that

LYRA

 How often.

BETHANY

 (long uncomfortable dramatic pause)
 (almost in tears)
 Every night.

LYRA

 Every night?

BETHANY

 Your what I want to dream about. My God, when you kissed me it was like I always knew I wanted to be with you. I've been lying to myself, my whole life I've been this good little Mormon girl who doesn't want to do anything wrong. Then I met you ... and you know

what?

> *Comes across the couch at LYRA and kisses her. LYRA is initially shocked but then returns the kiss. The two kiss passionately.*
>
> *BETHANY takes LYRA's hand and places it on her own breast. LYRA pulls away momentarily.*

LYRA

Beth, are you sure about this? A kiss is one thing, but if we go further it changes everything.

BETHANY

Is your mom home tonight?

LYRA

Much later, I guess. Sweetie ... think about this, ok?

BETHANY

Pour me a glass of wine, and take me to your room.

LYRA

(Pouring some wine in Beth's cup)

I just want you to be sure.

> *BETHANY takes her glass of wine and takes a large drink. Being this is the first time she has ever had wine she makes a face and puts the wine down. She then walks towards LYRA's room. LYRA follows.*
>
> *Just before they exit the stage they kiss again as the lights go down.*

Scene 4

> *LYRA's room. BETHANY is buttoning up her shirt*

> *and putting her socks on. LYRA is still in bed wearing an old shirt. BETHANY looks at her phone and notices several missed phone calls and texts.*

BETHANY

 Lyra, Lyra wake up. We fell asleep.

LYRA

 (sleepy)
 What time is it?

BETHANY

 Its 3 am. My parents are going to kill me. And I'm not doing the walk of shame with your mom in the house.

LYRA

 My mom doesn't care. That's why she didn't say anything when she saw you sleeping in my bed.

BETHANY

 This was a mistake. Can you take me home now?

LYRA

 Ok. Ok. Just let me get dressed.

BETHANY

 I'm sorry I said it was a mistake. It was wonderful.

LYRA

 Its ok.

> *They kiss again.*

BETHANY

 You still can't tell anyone.

LYRA

Sure sweety. Just don't forget about me.

LYRA has finished getting dressed. She and BETHANY go to exit.

BETHANY
 I can't forget you.

Lights go down.

Scene switches to BETHANY's house. WILLIAM is pacing back and forth in his robe, waiting for BETHANY to get home.

BETHANY enters

WILLIAM
 Where in the world have you been?

BETHANY
 Dad, I'm so sorry. I just ... lost track of time.

WILLIAM
 Does you phone not work?

BETHANY
 I'm sorry. I was at Lyra's my phone was on vibrate and we fell asleep watching TV.

WILLIAM
 This isn't like you to be so irresponsible. Something is going on, and I want you to tell me what it is.

BETHANY
 Dad ... its nothing. Just a lot right now with the break up, and Lyra was so cool to talk to ...

WILLIAM
 All right. Alright. But no more late nights ok? I'll

> let this one slide.

BETHANY
> I understand. Thanks Dad. Goodnight.

> *WILLIAM exits.*

> *ABIGAIL enters.*

ABIGAIL
> I heard you come home. Are you grounded?

BETHANY
> What are you doing up?

ABIGAIL
> I couldn't sleep. Thought I would get a glass of water. Heard you and Dad talking from the top of the stairs. Everything ok?

BETHANY
> Lets talk tomorrow.

ABIGAIL
> No, I want to hear about it now. Did you kiss her again?

BETHANY
> Yes. But this time ...

ABIGAIL
> What?

BETHANY
> Forget it.

ABIGAIL
> This time what ?

BETHANY

This time we went a little further ... I spent the
night with her.

ABIGAIL

Just sleeping?

BETHANY

We had sex.

ABIGAIL

Beth, kissing is one thing, but this is much, much
worse. You need to tell Mom and Dad.

BETHANY

There is no way I'm telling Mom and Dad.

ABIGAIL

So your some kind of lesbian now? Are you her
girlfriend?

BETHANY

Keep your voice down.

ABIGAIL

Answer my question.

BETHANY

Yes. I guess.

ABIGAIL

Beth you need to visit with the Bishop. You can trust
him.

BETHANY

I don't need to tell anyone until I'm ready to tell
everyone.

BEVERLY and WILLIAM Enter

BEVERLY

Well now you need to tell us. Because we heard what you were saying.

BETHANY

What part did you hear?

WILLIAM

If your going to keep secrets, don't do it in a quite house when your parents have their door open. Bethany I want to hear what happened.

BETHANY

(embarrassed)

I kissed Lyra ... ok. I kissed her and I like her ...

BEVERLY

Beth, Is that all that happened?

BETHANY

I don't want to talk about this. I'm old enough to make my own decisions.

WILLIAM

As long as your living here, you are going to live in a way that is consistent with the scriptures.

BEVERLY

Answer my question. Did you and this young lady have sex?

ABIGAIL

Mom, Dad. It's 4 am. Can you talk to her about this tomorrow.

WILLIAM

Abigail, you are excused. Go to your room.

BETHANY

Don't get mad at Abi. Yes, we had sex tonight.

BEVERLY
　　Oh Beth. Really?

ABIGAIL
　　Its not like that. She didn't mean to kiss her that night.

WILLIAM
　　Abi, did you know about this?

ABIGAIL
　　Yes. But she asked me not to tell you.

BETHANY
　　Its not her fault. Let her go to sleep. I'm going back to Lyra's.

BEVERLY
　　No. You are not to see that young woman anymore until we figure all this out.

BETHANY
　　You can not stop me from seeing her.

WILLIAM
　　Beverly, lets be reasonable.

BEVERLY
　　Don't you start.

WILLIAM
　　lets all calm down. Its 4 in the morning and we all need sleep. You girls head to bed, and tomorrow evening we will talk this out.

BETHANY
　　Fine.

ABIGAIL

Fine.

BEVERLY

 Fine.

WILLIAM

 Good ... we're all fine. You girls go to bed, I want to talk to your mother for a minute.

ABIGAIL and BETHANY exit

WILLIAM

 Alright, we have a bit of a problem.

BEVERLY

 Our daughter is gay.

WILLIAM

 I think our daughter made a huge mistake. But if we overreact this will have some serious consequences.

BEVERLY

 Where did we go wrong?

WILLIAM

 Lets not assume the worst OK. Kids do dumb things. Our girl is growing up and needs our support. I'm determined to love her no matter what.

BEVERLY

 Your insinuating that I don't love her?

WILLIAM

 I don't want to fight with you.

BEVERLY

 I wont have my daughter acting like that. It is shameful and disgusting and ...

WILLIAM

 And if we act like we hate her, she is going to start hating us.

BEVERLY

 I don't hate her, I just don't want a lesbian for a daughter.

WILLIAM

 Its day one. Lets not do or say anything we are going to regret.

BEVERLY

 Alright. But I don't like it.

WILLIAM

 Lets head to bed, tomorrow is going to be a long day.

BEVERLY

 I just can't believe it. Its like some kind of bad dream.

WILLIAM

 Lets go upstairs.

BEVERLY and WILLIAM Exit

Lights go down.

Scene 5

Classroom. Three "desks" with REUBEN, GEORGIA and BETHANY. BETHANY is texting LYRA during the class. Most of this scene will be on the "Big Screen" as text messages.

"So r u grounded" (LYRA)

"probably :) " (Beth)

"sorry"

"they will be ok"

"were they mad?"

"They found out we had sex"

"OM G !!! "

"Yeah"

"Guess you might as well come out now"

"not ready :("

"I miss your body"

"shh ... trying to concentrate. My parents made me come to school"

"I miss you. Come to my house after school for Round 2"

"maybe ... have to talk to my folks. Class is over, ill text you soon"

"ok ... can't wait to see u again"

"ttyl"

REUBEN
 Beth, how are you?

> *BETHANY goes to slip her phone into her purse but misses the outer pocket and it falls onto the floor. Distracted by REUBEN she doesn't notice. As she picks up her purse, her phone lies conspicuously on the ground under her desk.*

BETHANY
(coldly)
Hi Reuben. Hello Georgia. Hello Georgia and Reuben.

GEORGIA
(coldly)
Bethany. Good to see you are talking to us again.

BETHANY
yeah, well, don't get used to it. My mother taught me if I don't have anything nice to say ... don't say anything at all.

GEORGIA
Look Bethany. I know you think I stole Reuben from you but ...

BETHANY
Your with Reuben now?

REUBEN
Georgia I told you that I wanted to tell her nicely ...

GEORGIA
Look Reuben, she's being a little bitchy about the whole thing and I thought it would be a good idea to just get it out there and ...

BETHANY
Wow ! Bitchy.

REUBEN
Come on, lets not fight.

BETHANY

You two deserve each other. Thanks for sticking up for me Reuben. Enjoy your new girlfriend.

BETHANY quickly exits leaving her cell phone behind.

GEORGIA

What did you ever see in her?

REUBEN

Leave her alone ok.

GEORGIA

Yeah, fine. Whatever.

GEORGIA notices BETHANY's cell phone on the ground. REUBEN does not see it.

GEORGIA

Hey, why don't you try to go talk to her. She hates me, but she probably doesn't hate you as much. I'll catch up with you later.

REUBEN

Yeah, that's probably a good idea. I'll see you tonight?

GEORGIA

You will.

REUBEN exits

GEORGIA picks up BETHANY's cell phone off the ground and opens it.

She reads the text messages ...

GEORGIA

> (To herself)
>
> Oh my ... little Bethy has a secret. I wonder if Reuben will think so highly of her now.
>
> *GEORGIA continues to read the texts just as BETHANY enters*

BETHANY

Is that my phone?

GEORGIA
> (startled)
>
> Is it? ... because the Bethany I know has never had sex with a girl before

BETHANY

What did you read?

GEORGIA

All of it. I read all of it Beth and you need to explain what these text messages are all about.

BETHANY

I don't have to explain anything to you.

GEORGIA

Oh no? Well, seems Lyra has been busy texting you a few pictures as well. Busty little girl - didn't get that from the hoodie she was wearing that night. The nighty was a nice look ... let me ask you, does that turn you on seeing her like that?

BETHANY

My life is none of your business.

GEORGIA

I'm making it my business. How long before you and Reuben broke up were you and her having lesbian sex?

BETHANY suddenly grabs for the phone from GEORGIA's hands, causing GEORGIA to trip over a chair behind her. As she does she twists and ankle.

BETHANY grabs the phone and runs from the room.

GEORGIA

 (Yelling at Beth offstage)

YOU BITCH !! I'm telling him. I'm telling everyone. Your done Bethany. You perfect little Lesbian.

REUBEN enters and observes GEORGIA struggling to get back to her feet.

REUBEN

What happened?

GEORGIA

Your little friend Bethany attacked me. Pushed me over that chair and I think I broke my ankle.

REUBEN puts his arm around her and helps her walk. GEORGIA is in obvious pain, but is probably playing it a bit to get sympathy from REUBEN.

REUBEN

Lets get some ice on that ankle. I'll take you to the nurse.

GEORGIA

yeah. On the way, I want to tell you a little something about Bethany that you might not want to hear. My phone is in my purse, I forwarded a conversation between her and Lyra. And a few pics too. I think you need to know everything that has been going on.

REUBEN and GEORGIA Exit

Lights go down.

Scene 7

Scene opens with BETHANY walking home and checking her phone. These texts come up behind her and they stay on the screen. The effect will be "filling" the screen with these.

"Can you believe she had sex with that new Gay girl?"

"Her parents must be so ashamed"

"Poor Reuben"

"DYKE

"HOAR"

"God made Adam and Eve, Not Amanda and Eve"

These play in succession. BETHANY hangs her head, turns off her phone and the text messages dissapear.

Lights down.

Lights down

Lights come up on REUBEN and GEORGIA sitting on a couch.

REUBEN
 I just can't believe it.

GEORGIA

You've seen the text messages. If you ask me she was cheating on you all along.

REUBEN

We don't know that.

GEORGIA

Come on. That Dyke worked you like a ...

REUBEN

Don't call her that.

GEORGIA

She is.

REUBEN

Just don't call her that.

GEORGIA

What is this power she has over you? Tell me, would you rather be with her or with me. Because sweety, when I'm with you ... I'm with you. When she kissed you, she was thinking about her.

Georgia goes to kiss Reuben but he pulls away.

REUBEN

It was very cruel, forwarding those texts and that picture of Lyra.

GEORGIA

Oh poor baby. She needs to pay for her sin. Heavenly Father is not pleased with her, she deserves everything that is happening to her.

REUBEN

Still.

GEORGIA

Reuben, have you thought about us ... taking this relationship a bit farther?

REUBEN

No. I mean ... yes. I mean, I would like to ... how much farther?

GEORGIA

Well ... why don't you come upstairs. I'll show you. Just one thing. If you want to see these (*Pointing to her breasts*) you have to promise me that you will have nothing to do with your Lesbian ex-girlfriend.

REUBEN

Blackmail?

GEORGIA

No sweety. Not blackmail. It's either me or her. Let me know. Her room ... or mine.

Georgia exits. Reuben sits on the couch for a long moment and then finally joins Georgia and they walk offstage together.

Scene 8

Lights come up on BETHANY's family room.

BEVERLY, WILLIAM, ABIGAIL and BETHANY are seated

WILLIAM

Alright. Abigail, Bethany has asked that you be here. Otherwise, this conversation would not include you. Bethany, as you know your mother and I picked you up from school today from the principals office. It was a miracle that your principal did not suspend you

for hurting Georgia. I want you to explain yourself
please. Your mother and I are listening.

BETHANY

She stole my phone. She read a bunch of private text
messages between me and Lyra and ...

BEVERLY

You and Lyra? What kind of text messages Beth?

BETHANY

Bad ones.

BEVERLY

Have you sent her anything revealing?

BETHANY

No! Georgia was making fun of me and I just wanted my
phone back and when I went to get it she fell. I don't
think she broke her ankle or anything ...

WILLIAM

I think the bigger issue here is how you have been
acting since you met this Lyra person.

BETHANY
 (Angry)
This has nothing to do with her. It's all me. OK. I
am confused, and it hurts that I can't tell anyone what
is going on.

ABIGAIL

Beth, you told me about this before you told
them. Ever since that day your not the same sister I
knew. You have changed ... your not following God's
Plan of Happiness. Everything that you have been
taught ...

BETHANY

> (gets up and heads towards the door)
> Whatever.

BEVERLY
> Where do you think your going?

BETHANY
> Away.

WILLIAM
> Don't storm out of this house ! You want someone to listen to you, someone to talk to ... talk to us.

ABIGAIL
> Please Beth ... listen to them.

BETHANY
> (Almost crying)
> Why? What's the point? Everyone knows, ok? You should see the texts I'm getting ... the stuff on Facebook about me, the stares I have been getting in school ... What is wrong with me?

WILLIAM
> There is nothing wrong with you ... but you've made a bad choice to have sex with this young ...

BETHANY
> OH ! So I deserve this? I deserve to have my private life on display for everyone to see?

WILLIAM
> No ... that's not what I meant ...

Bethany heads towards the door.

BEVERLY
> (Very Angry)

You walk out that door don't think your coming home tonight. We are not done talking to you and you will not disrespect this family by walking out.

BETHANY
> (Angry)

I don't want to be here tonight. I'm going to Lyra's house.

BEVERLY
You are not spending the night at that girls house.

WILLIAM
Beth, come back and sit down.

ABIGAIL
Bethany, please. I'm sorry for what I said ... don't leave. Listen to them.

BETHANY
I would rather be where I am accepted. I'll be at my girlfriends and when you are all ready to accept who I am call me.

BETHANY exits

ABIGAIL
I know where Lyra lives ... do you want me to go get her?

WILLIAM
Let her cool off.

BEVERLY

Abigail, your father and I need a minute.

ABIGAIL
 Ok.

ABIGAIL exits

BEVERLY
 I can't do this William. I can't have my daughter out at night having sex with that ... daughter of perdition.

WILLIAM
 I know your upset. But we promised to always love our girls. No matter what.

BEVERLY
 I love her, but I don't support this behavior. She can't stay here if she is going to keep living this way.

WILLIAM
 I won't allow you to make that decision.

BEVERLY
 As head of this household you have that right. But I'm telling you, for tonight at least, our daughter is not coming home unless she promises to never see that Lyra girl again.

WILLIAM
 Let her be for tonight. She is going to stay at Lyra's, at least she will be safe. We will talk with her tomorrow and arrange for her to meet with the Bishop. Can we at least agree on that?

BEVERLY
 I don't like it, but Ok.

WILLIAM

 Thank you Beverly. Lets try to enjoy the rest of the evening ok. I'm sure we will see Beth tomorrow.

Scene 9

LYRA's house. She is sitting on the sofa with her laptop computer open (hidden from the audience)

She hears the doorbell ring and goes to answer the door.

BETHANY enters

LYRA

 What are you doing here?

BETHANY

 I had to leave my house. I want to stay with you tonight.

LYRA

 (angry)
 Can I show you something?

BETHANY

 What's wrong?

LYRA

 Why did you send this picture to Georgai? And who else has seen it ?
 (LYRA points at the laptop)

BETHANY

 Oh God ! She emailed it from my phone.

LYRA

 Why did Georgia have your phone?

BETHANY

 Lyra I am so sorry.

LYRA

 Am I a joke to you?

BETHANY

 What? No! What do you mean?

LYRA

 Have some fun with the Gay girl?

BETHANY

 What are you talking about? Lyra, tell me what is going on?

LYRA

 I sent you those photos in private. Now you tell me that someone else went through your phone and managed to see those pictures? What the hell is wrong with you?

BETHANY
 (almost in tears)
 Don't be angry. It was a mistake. Those pictures ... the text messages ... she stole them from my phone.

LYRA
 (Angry)
 Stop crying. Your pathetic. Just wanted to see what it felt like to be with a woman? Your like some teenage boy that wants to get his balls off. Wanted to brag about your accomplishments?

BETHANY
 (Angry)
 You don't want to hear me at all ! When you sent them they were in my email. I left my phone ... you know, I

don't even want to explain it again. I'm sorry they got out, but I never asked you to send them in the first place. I'm going home. This whole thing, this thing with you and I and making love to you ... huge mistake.

LYRA
> (Angry)

Someday think about someone other than yourself, you prissy little Bitch!

BETHANY

That is the second time someone has called me that. I expected it from the first girl, but I never thought I would hear it from you. Goodbye Lyra.

> *BETHANY goes to leave, LYRA steps in her way and blocks the door*

LYRA

Wait ...

BETHANY

Get out of my way !

LYRA

I'm sorry ... I'm just angry.

BETHANY

Please, don't ... just move so I can go home.

LYRA
> (moving)

Fine. But don't call me ok. I am no one's mistake.

> *LYRa walks away from the door. BETHANY pauses, unsure whether to leave or stay. Finally, after a long pause, she opens the door and exits.*

Scene shifts to BETHANY trying to find somewhere to stay that night. She is sitting at a bus stop.

She calls home and BEVERLY answers.

BEVERLY
 Hello?

BETHANY
 Mom its me. I want to come home.

BEVERLY
 After what you pulled tonight? Why aren't you at Lyra's.

BETHANY
 We had a fight ok. Can Abigail come get me?

BEVERLY
 No. You want to be grown up, you figure out a place to stay tonight. Your father, sister and I don't feel like we want to put up with your dramatics again. We will talk to you tomorrow night, but you better believe you are going to have to repent. You can come home after you have met with the Bishop.

BETHANY
 I want to talk to Dad.

BEVERLY
 Bethany I can assure you he feels the same way. Now goodnight. You have plenty of friends to call.

BEVERLY hangs up the phone and exits the stage

BETHANY tries calling REUBEN.

REUBEN

 Hello?

BETHANY

 Reuben, its Beth

REUBEN

 What do you want?

BETHANY

 I need a place to stay tonight.

REUBEN

 Why don't you stay with Lyra? I know about you two.

BETHANY

 Oh God Reuben. I never meant for you to find out this way.

REUBEN

 You never wanted me to find out. You know what you did was wrong, but you made me feel so horrible for cheating on you but you were doing the same thing.

BETHANY

 Please ... I have no where to go.

 GEORGIA, who has been listening to the phone call takes the phone

GEORGIA

 Bethany, this is Georgia. I would appreciate it if you would please leave my boyfriend alone. You had every chance to talk to him and ask him for forgiveness.

BETHANY

 Georgia? Put Reuben back on. This is none of your business.

GEORGIA
> Reuben is very happy with me. Anything that affects him is my business, and I don't appreciate his ex-girlfriend calling him and asking to spend the night. Goodnight Bethany.
>
> *GEORGIA and REUBEN hang up on BETHANY.*
>
> *BETHANY wanders downstage, while other text messages display on the screen behind her*
>
> *These are added to the original text messages and they fill up the screen in a hectic, confusing manner one on top of another.*
>
> *Last word on the screen is DYKE*
>
> "Your Girlfriend is hot, nice pic !"
>
> "Can't find a man? "
>
> "Your going to hell, you know that"
>
> "What's wrong with you?"
>
> "I thought you were with Reuben, didn't he make you happy"
>
> *BETHANY finds herself wandering through the streets of Provo. Her phone rings but she doesn't answer it. She turns the phone off and puts it in her purse.*
>
> *She sits down at the bench finds a broken bottle under the seat. She picks up the broken glass ...*
>
> *She tests the sharp piece of glass on her skin and*

then puts it down. She puts her head in her hands, looks down at the sharp piece and makes a small cut on her arm ...

Scene shifts to WILLIAM and BEVERLY trying to call BETHANY on the phone.

WILLIAM
　　It's just going to voice mail.

BEVERLY
　　I'm sure she is fine.

WILLIAM
　　I'm going to look for her.

　　　　ABIGAIL enters

WILLIAM
　　ABIGAIL, I want you to go to Lyra's house and ask her about Bethany. She probably has already gone back to her house.

ABIGAIL
　　Ok. Where are you going?

WILLIAM
　　I don't know. I'm going to head out and start looking for her. Beverly, keep calling her. If you hear from her call me and tell me where she is.

BEVERLY
　　You are overreacting.

WILLIAM
　　Telling our daughter that she can't come home is probably the worst thing you could have done.

WILLIAM and ABIGAIL exit

BEVERLY picks up the phone as the lights fade.

Lights come back up on BETHANY sitting on the bench. She is holding the broken piece of glass. Still testing it on her arm and on her wrist, but nothing more than small cuts.

BETHANY
(to herself, praying to God)
My dear, kind Heavenly Father. I ask Thee ... You know what, Never mind. You've probably abandoned me too.

Bethany laughs nervously and looks around her again. She cuts a little deeper this time, still testing the pain on her arm ... a little deeper this time.

I wanna be in her arms. But you don't like that. You don't like us loving each other. You want me to be straight, but I'm not. I'm gay and I like girls instead of boys.(*Laughing uncomfortably*) And you allow everyone to say hurtful, angry things to me. I am a Dyke.(*Laughing*) I am worthless

BETHANY rolls up her sleeve and slowly starts to deeply cut herself with the broken glass.

She cries in pain ... but continues.
I deserve this.(*Laughs*) I'm going to hell.(*Laughs*) That will make you happy (*Laughs again*) I deserve everything I am going through because I broke your rules. And when I break your rules I deserve to be hurt ... to feel this pain.

BETHANY uncontrollably cuts herself again ... and again. Finally she cuts hard and too deep and screams in pain.

Oh God !! Dad ... Mom ... I'm sorry.

BETHANY grabs for her purse, trying to find her phone. She finally finds it but just as she turns it on she realizes the amount of blood pouring down her arm. She collapses at the sight of her own blood ... The phone falls beside her, she never made the call.

The phone rings.

"4 voice messages"

Voice mail plays in Voice over as the lights dim on Bethany.

"Bethany this is your father. Please call us back. You need to come home."

"Bethany, your worrying me. Please, give me a call. I've spoken to your mother and there has been a big misunderstanding. You are always welcomed here, no matter what we love you. Please call."

"Bethany, I'm going to try to find you."

"Bethany, this is your mother. I'm sorry for what I said and I want you to come home. No matter what happens your my daughter. Your father, sister and I are so worried. Please, call us back."

Lights slowly fade on the phone and on Bethany.

Scene 10

Funeral. Stage is set with a casket and a photo of Bethany on top of the casket.

The cast walks in single file and stands to left and right of the casket.

WILLIAM

I have been asked, by people with good intentions, what we could have done better. I suppose, in the months and years ahead all of us will be pondering that question. I can't speak for anyone else. But personally, right now, I would answer that question by saying this "Bethany I love you. I love you just the way you are. Don't ever change, because you are a child of God. "

ABIGAIL

I can't believe that this happened. I wont be able to say a lot (*Crying*) I love you Bethany. I love you.

ABIGAIL goes to say something else but realizes there is nothing more to say. She walks back into the darkness where BEVERLY and WILLIAM hold her. GEORGIA approaches LYRA and she accepts GEORGIA'S embrace.

As the lights go down music swells. Pinlight on the photo.

During this, the screen plays names of those who have killed themselves because of bullying and misunderstandings.

"Tyler - 2010"

"Ryan - 2003"

"Megan - 2006"

"Rehtaeh - 2013"

"Jamey - 2011"

"Audrie - 2012"

"Amanda - 2012"

End.

Friday A Play in One Act

By

Jason Isaac Kooy

Jason Isaac Kooy
jisaackooy@gmail.com
403 690 9960

Cast of Characters

JOE: A forty-something recently divorced male.

MARY: His ex-wife.

SARA: Joe's oldest daughter; early to mid twenties. Estranged.

MO: A figment of Joe's imagination, only seen and heard by Joe.

ACT I

Scene 1

Interior of JOE's apartment. Present Day.

The apartment is shoddy There are bottles lying Around. JOE has one in his hand.

JOE and MARY are arguing.

JOE

 (Shouting)

WHAT DO YOU MEAN YOUR NOT LETTING THEM STAY HERE THIS WEEKEND?!

MARY

You need to calm down.

JOE

THEY ARE MY KIDS TOO. YOU CAN'T TAKE THEM AWAY FROM ME!

MARY

You're drunk. The kids are safer with me.

JOE

I'm not drunk. I just had a few after work.

MARY

You're holding a bottle in your hand.

JOE puts the bottle down. Turns to see MARY heading towards the door.

JOE

I'm sorry, okay. I won't drink anymore.

MARY

You made that promise last week ...

JOE

I'll go to meetings again ...

MARY

Yeah ... whatever.

JOE

I mean it this time.

MARY

The kids are staying with me this weekend.

JOE

(Angry and aggressive)

DON'T PUSH ME ON THIS! OR YOU'LL REGRET IT.

MARY

(Concerned)

This is why I had to take the kids and go. The violence, the drinking ... the threats.

JOE

If you don't let me take the kids this weekend I'll make sure you never see them again.

MARY

You're sick.

MARY heads towards the door. JOE rushes in front of her and blocks her)

JOE

Where do you think you're going? We're not done talking.

MARY

Get out of my way !

JOE

 I'll let you go as soon as you let me see my kids.

MARY

 (Angry, yet composed)
 Please move. We'll talk tomorrow. Ok?
 (Frightened) Just let me go.

JOE

 No. You're going to sit down there and listen to what I have to say.

MARY

 You're scaring me. (near tears) Please, just let me go home and take care of the kids and ...

JOE

 Scaring you? I'm scaring you? ...

MARY

 I just want to go.

 MARY tries to push her way past JOE.

 JOE grabs MARY and physically intimidates her. She tries to get away but JOE pushes her to the floor. He stands over her, wild look in his eyes, until it hits him what he has done to her.

JOE

 I'm so sorry ... oh my God, I never meant to hurt you. Are you hurt? I'm so sorry ...

 MARY is terrified, but composes herself. She moves quickly towards the door. She pauses just long enough to address a visibly shaken JOE

MARY

> Its over ... all of it. I'll pray for you, but don't even try to call me.

MARY quickly exits

JOE watches her leave and tries to pursue her, but realizes she has gone

JOE takes a long beat and then getting angry picks up the bottle of Vodka

JOE

> Pray for me. Don't you dare pray for me. You can take every prayer that you were ever going to pray and stick it up your ass. I don't want your prayers. I don't want you.
> (Looking up towards God)
> I don't want you either. So Piss off. All of you.
> (Taking a swig from the bottle)
> This ... this I want.

JOE takes another swig from the bottle, sits back in his chair. He is drunk and exhausted

JOE

> (Singing to himself)
> When the rain is blowin' in your face / And the whole world is on your case / I could offer you a warm embrace / To make you feel my love.
> (Talking to himself)
> Was that the song? Is that what we danced to? What happened?
> (Singing again, softer)
> To make you feel my love ...

JOE finally nods off in his chair and the bottle (now empty) falls from his hand and rolls across

the stage

Lights go dark

Scene 2

A week later. JOE has not heard from MARY or the kids.

JOE has been drinking; he picks up a piece of paper and starts reading aloud. It is a restraining order that was served to him the previous week.

JOE

 (reading out loud)
Not to have any contact with Mary Andrews, Cathy Andrews, Judy Andrews ... 500 meters.

JOE goes to pick up the phone to call MARY.

Mo appears out of the shadows.

MO

That would be a violation of the restraining order.

JOE quickly hangs up the phone. He is momentarily surprised, but quickly recognizes him.

JOE

Took you long enough to get here. Want a drink?

MO

No, and I don't think we should be drinking anything else today.

JOE

Don't tell me not to drink. (beat) Who are you again?

MO

 I'm the part of you that has to escape when you get like this.

JOE

 You never make any sense.

MO

 Think of me as the remains of any sense or sensibility that hasn't been pushed completely out of your life.

JOE

 How do I get rid of you again?

MO

 You tell me to go, I go.

JOE

 Just like that.

MO

 Just like that. But you don't want me to go right now.

JOE

 I could use the company.

MO

 So what's going on?

JOE

 Mary served me this restraining order. I didn't know you could get one that quick.

MO

 You must have scared her pretty bad.

JOE

 I threatened her and the kids.

MO

 I appreciate your honesty. I already knew that ... but thanks for being so honest with me.

JOE

 Why did you ask?

MO

 Admitting you have a problem is the first step.

JOE

 I didn't mean it.

MO

 Words are funny things. Consider what a great forest is set on fire by a small spark. The tongue also is a fire, a world of evil among the parts of the body. It corrupts the whole body, sets the whole course of one's life on fire, and is itself set on fire. Unfortunately, that was kind of the straw that broke the camel's back for Mary. Right now she is figuring out how to get you out of her kid's lives; and I don't blame her.

JOE

 I said I didn't mean it. She always takes everything I say so literally.

MO

 We never mean most of the stuff we say.

JOE

 I need to make this right.

MO

 Is that what you want?

JOE

I'll do anything.

MO

I can't tell you what to do, but you're right. You should do something.

> *JOE suddenly gets an idea and grabs the restraining order off the table. He is trying to read it quickly and finally slows down and takes his time. MO is quite amused by this.*

MO

How many times have you read that? It's getting a little pathetic ...

JOE

She isn't listed.

MO

Who?

JOE

Sara, my oldest daughter.

MO

The one you haven't talked to in three years?

JOE

It hasn't been three years ... has it?

> *MO nods her head smugly*

JOE

OK, whatever. I'm going to go see her.

MO

Are you sure about that? Maybe you should think this through ... you haven't been father of the year. Not even sure they would let you attend the ceremony ...

JOE

I have to do something - and she is the only one I can talk to...legally.

MO takes a long time to answer and then finally resigns herself to agreeing with JOE

MO

Well ... all right then. Can I come?

JOE

Do I really have a choice?

MO

Not really. When are we doing this?

JOE

Right now ... (putting on his jacket) You coming or not?

MO

I'll meet you there. Do you have to go right this moment? I just remember the last time you tried to talk to her and ...

JOE exits

Mo realizes she is talking to herself

MO

So that's what that feels like. No wonder he hates it when I just disappear.

Lights go down

SCENE 3

Sara's house. She is sitting at the table reading a book when suddenly there is a knock on the front door. Sara puts her book down begrudgingly and goes to answer the door. She is shocked to see her estranged father standing in the doorway

SARA

 What are you doing here?

JOE

 Can I come in?

SARA

 Mom said that you might come by.

JOE

 So you've talked to her.

SARA

 Why are you here? Need some more liquor? Weed? Pills?

JOE

 How about some coffee?

SARA

 You can buy your own damn coffee.

JOE

 Can I come in?

SARA

 Fine ... come in. Is this going to take long?

JOE

 Is there a reason why you're being so rude to me?

SARA

> The very fact that you have to ask me that is pretty damn disgusting.

JOE

> So you've talked to mom.

SARA

> She told me what happened; you pushing her down, threatening my sisters ... Is there something she didn't tell me?

JOE

> Sounds like she covered all the bases.

SARA

> So what do you want? Why are you here?

JOE

> Look, you're the only one I can actually talk to right now ...

SARA

> Don't even start.

JOE

> I just want to make things right between us and ...

SARA

> AND WHAT? You've had three years since I moved out to make things right. But we haven't talked. And sure, some of it is my fault, but not everything. I have spent the last three years hating you for what happened and I am not ready to kiss and make up.

JOE

> I have replayed that moment in my head over and over

...

SARA

But what have you done about it? NOTHING! And that is what you are to me now ... Nothing.

JOE

That's enough!! I'm still your father and you don't have any right to talk to me this way.

SARA

I'm just getting started JOE !

JOE

Don't use my first name.

SARA

Or what Joe? You're going to hit me, Joe? You're going to make me cry like you did three years ago? Tell me, was she worth it?

JOE

(getting Angry)

That's a bunch of crap. You're just like your mother, little miss know it all with all the right answers. Thought you could do better, so you moved out with your boyfriend when you were 16 ...

SARA

I moved away from you. Oh, it was cool having a father who let me do weed when mom wasn't around ... but I came to my senses and had to get away from you.

JOE

You dropped out of school.

SARA

I got my GED ... not that you showed up at the ceremony.

JOE

 This was a mistake. I'm leaving ...

 JOE goes to leave but MO suddenly appears and stops him

MO

 Don't walk out of her life again. If you do, you will never get her back.

JOE

 Leave me alone. Get out of my way.

SARA

 I'm over here. I'm not in your way.

MO

 Save yourself the embarrassment. She can't see me.

JOE

 (to SARA)
 I'm not talking to you.

SARA

 Then who are you talking to? Are you off your medication again?

MO

 Told you ... go talk to her.

 JOE slowly takes off his jacket and returns. He sits back down at the table.

SARA

 I thought you were leaving.

JOE

 Can we just talk about something other than how much

damage we have done to each other? Did I do anything right?

SARA

You fixed my car once.

JOE

I mean as a father. Did I do anything right as a father?

SARA

If you're looking for some kind of Oprah moment here between the two of us ... that is not going to happen.

JOE

Are you still writing?

SARA

Why do you care?

JOE

What are you writing? Songs? Stories?

SARA

Poetry ... not that you would know that.

JOE

Can you read me one?

SARA

Roses are red / violets still grow / the man I used to call Daddy / I now call Joe.

JOE

Clever

SARA

You want to hear me perform, find an open mike night
somewhere ... Maybe I'll be performing.

JOE

Can you give me a clue? I'd love to hear you ...

SARA

Stop with the promises, we both know you won't be
there. You'll be drunk, probably out with that
girlfriend of yours ...

JOE

I don't have a girlfriend. She left me.

SARA

You are so pathetic ...

JOE

Can I do anything right?

> *SARA takes her time to answer this. Then she
> thoughtfully answers*

SARA

I honestly can't think of anything.

JOE

Nothing?

SARA

Maybe in another life we get to start over. But as far
as this life goes ... I just don't see it. I don't
have enough faith to believe that you and I can ever be
friends - much less father and daughter. And please
understand, I'm not just trying to be difficult. I
have spent nights wishing for a real father - a man who

could answer every one of my dreams and still dance
with me like we did when I was a little girl.

JOE

You remember that?

SARA

Home movies.

*JOE drifts back in his memories and starts to sing
to himself*

JOE

 (singing)
Sleep / sleep tonight / and may your dreams / be
realized ...

SARA

What was that song?

JOE

What song?

SARA

Just now, you were singing to yourself ... where do I
know it?

JOE

It's an old U2 song ... I used to sing it to you. I was
the only one who could get you to sleep.

SARA

I hear that song every time I am unhappy ... It always
cheers me up.

JOE

Yeah. Makes me happy too. You were such a beautiful
baby. All you kids, are just beautiful.

SARA

What was that other one ... the one about slowing down or whatever?

JOE

(signing)

Baby slow down / the end is not as fun as the start / please stay a child somewhere in your heart

SARA

That was you?

JOE

I used to sing that one to you as well.

SARA

I love that song.

JOE

I've made a mess of things

SARA

We kinda both have.

JOE

How do I ask you to forgive me?

SARA

You ask. Just ask.

JOE

Please ... forgive me.

SARA

I love you out of some obligation that says a daughter is supposed to love her father. Then I think of you, and everything you have tried to do to destroy this

family and it's not love that I feel towards you. Its
not hate either ... it's this tangible apathy towards
ever allowing you to know me as your daughter. So I get
up, I write a poem - I sing a song ... I pray to a God
that must be there. But I don't even consider
forgiving you. I can't be any more honest than that.

JOE

I do understand.

SARA

But if it makes you feel better, I'm closer to
forgiving you then I was this morning.

JOE

One day at a time right.

Sara grabs an advertisement flyer from the table

SARA

Here

JOE

What's this?

SARA

The next open mic night. You should come.

JOE

I'll be there, I promise.

SARA

I'd like that. Keep that promise and we'll go from
there. Like you said, one day at a time.

JOE

Wouldn't miss it for the world. Do you do any of that
spoken word stuff ... crazy rhymes to the beats

SARA

 Please don't try to be cool.

JOE

 Fair enough. I should get going. I'll see you here.

 JOE gives SARA an awkward hug and exits

SARA

 I hope so, Joe. I hope so.

 Lights go down

Scene 4

 Interior of JOE's apartment. He enters and hangs up his jacket.

 MO appears

MO

 Well, that was good.

JOE

 It went well ... not gonna lie.

MO

 So anything else you need to do on your day of redemption? It's been a busy day for you ...

JOE

 What else is there?

MO

 God.

JOE

 What about him?

MO

 You told him to, and I quote, "piss off".

JOE

 I didn't mean it.

MO

 Really? We need to get you a new argument.

JOE

 What, you want me to tell God I'm sorry?

MO

 Are you?

JOE

 Not really.

MO

 That's unfortunate.

JOE

 I'm mad at him right now.

MO

 Why are you mad at him? What did he do?

JOE

 He could fix everything right now with Mary and the kid's if he just snapped his fingers ...

MO

 That's what you want? No personal responsibility? You just get to rub on some magic lamp and say "Fix it, God! Oh, I know I've screwed it up, but please ...fix it this one time and then I will never ask for anything else again ... blah blah blah."

JOE

 That's a little bit of an exaggeration.

MO

 So is wishing for a God that would change them and not change you.

JOE

 Why does he create me to be sinful yet hate the sin? Tell me that ... you have all the answers tell me that.

MO

 No, I don't.

JOE

 You don't what?

MO

 I don't have all the answers. I never did. I'm not all-knowing ... I just tend to exaggerate the logical parts of what you already know. I don't know why God is the way he is any more than you do ... but he is what he is for a purpose and our job is not to dictate to him how to fulfill that purpose.

JOE

 Don't preach to me.

MO

 You want me to go? Just say the words and I'm gone. But you can't get rid of him that easily!

 JOE ponders this for a long beat then finally decides

JOE

 I'm not ready to deal with all this right now, so maybe

just give me a minute to decide how to handle this and ...

MO exits suddenly

JOE

MO? Mo where are you? Come on, this isn't funny you can't just leave me like this. God dammit, Mo.

JOE picks up an empty bottle sitting next to him on the table and violently throws it off-stage. He storms back, finds a full bottle, unscrews the to, goes to drink, but stops himself. He goes to drink one more time but stops himself again

JOE

(To God)

So I don't know what the deal is with you and me. I don't have a lot to talk to you about. But I do fee like I should apologize to you. So here's the deal; I'm sorry you created me to be an alcoholic.

JOE's left arm is starting to bother him, and he finds a chair as he is starting to feel like he needs to sit down.

You didn't give me much of a father. That old drunk died years ago, with a bottle in his hand and a laundry list of regrets.

JOE is rubbing his left arm now and is starting to feel noticeably ill on stage. He grimaces in pain and the words are coming out more painful.

I don't want to be like him ... I want to be a good father ...

JOE is in very obvious distress. He is in intense pain and on the verge of a heart attack.

> Please ... forgive ... me.
>
> *As JOE says this he cries out in pain and falls forward to the ground motionless. It is quiet and still for a few moments.*
>
> *MO enters*
>
> *She sits next to JOE and waits quietly.*

Lights go out

Scene 5

> *JOE is still lying on the floor with MO sitting next to him*
>
> *JOE wakes up; still in a lot of pain*

JOE

> What happened? Am I dead?

MO

> Yes.

JOE

> OH NO! Why am I still in my apartment?

MO

> I'm just kidding. You're not dead. Could you imagine? Heaven turns out to look just like your studio apartment?

JOE

> Am I dead or not?

MO

> Nope ... you had what we like to call a major panic
> attack. All the pain of a heart attack without any of
> the death.

JOE

> Mary?

MO

> What about her?

JOE

> Does she even know what happened to me?

MO

> What happened to you? You'll be fine.

JOE

> I could have died and she wouldn't even care.

MO

> What do you expect out of her? You are an abusive
> Alcoholic.

JOE

> I just thought ... you know, I prayed .

MO

> I heard.

JOE

> So I figured that things would start to change.

MO

> Joe, the wages of sin are death. You may have made
> things right with God but there are still consequences
> to your actions.

JOE

So that's it.

MO

That's it.

JOE

Nothing I can do?

MO

She isn't the only one in your life.

JOE

What time is it?

MO

Six pm ... you've been out for about 24 hours or so.

JOE

And you didn't call for help?

MO

No one else talks to me, remember?

JOE

Right ... wait. What day is it?

MO

Saturday

JOE

Saturday? At six?

MO

Yes. Why?? What's so important??

JOE

Open mic night. How do I look?

MO

> Like you've been passed out for 24 hours on the floor of your apartment. You might want to clean yourself up.

JOE

> What should I wear?

MO

> I'm not that kind of hallucination.

JOE

> You're a woman, aren't you?

MO

> Thanks for finally noticing ! Your sexist comment warms my heart.

JOE

> Should I bring her something?

MO

> How about a flower.

JOE

> Yeah ... she likes those. I think. Wish me luck.

MO

> Good luck Joe. God speed. You look nice by the way.

JOE exits

MO

> I'll miss you Joe.

Scene 6

A bar. JOE enters and looks around. No sign of SARA. He takes a seat and waits. After a few

> *moments SARA enters. She sees JOE and goes over to his table.*

JOE

 Am I too late?

SARA

 No, I'm up next. I can't believe you came.

JOE

 Didn't think I'd make it?

SARA

 No. To be honest I didn't.

JOE

 I brought you a rose.

SARA

 It's beautiful ... I can't believe it ... the poem I wrote is all about ...

JOE

 All about what?

SARA

 It's my turn. Just stay here ... don't go anywhere, okay?

> *SARA takes her place nervously on the stage. She starts the poem, stops, and then starts again ...*

SARA

 I was given a flower once by a man who said he was my father
 A simple rose, red, dying
 I pressed it between the memories of a moment that was and a moment that will never be and I let it be
 A wish A regret A desire so out of my world it might as

well be a distant planet orbiting an even farther star ... hopes die at that age, the intersection of reason and wisdom is a teacher who gives the test and then shows you the answer ... puts an F on your paper and tells you that no matter how hard you wish upon the distant star it does not move closer to your orbit I instead move towards it ... hope be damned its not enough to hope for it when you board your ship and countdown the trip which takes you to whatever star, however far, however long the journey it has to be worth it in the end because my life's journey is not played out in the pages of what if – but what could be. If the man with the flower could see the beauty of the star that is me.

> *SARA walks back to JOE. JOE meets her halfway and they embrace.*

Lights fade.

> *THE END*